Praise for *On Alchemy*

"There's no sounder or more sage guide to alchemy than Brian Cotnoir. This wise, lucidly written book is his canonical distillation: here, in concentrated but lucid fashion, he offers explanations and exercises that will be of immeasurable help to anyone hoping to navigate this enormous field. Ways of seeing are complemented by ways of doing. The result is equal parts intellectual toolkit, spiritual guide, and vision of a brave new/old world."

Sukhdev Sandhu, Director of the Colloquium for Unpopular Culture at New York University

"Magister Cotnoir distills and multiplies his ideas and sources with easy and unforced erudition. Finally, a book on Alchemy that tells us what to *do*."

Hymenaeus Beta, Frater Superior, OTO

"Brian Cotnoir's study of the Royal Art is here distilled in a form perfect for the student of alchemy and for those seeking to use the ideas, concepts and discipline of alchemy in their own creative practice. Densely packed with Cotnoir's lifetime of knowledge

and experience, the text flows easily from one idea to the next with a concise style so often missing from works on the subject. Alchemy's wisdom is not easily acquired; its concepts lurk on the margins of our modern experience, kernels preserved in seemingly unlikely places, until through study, one realizes the ideas speak to the core of being. This book creates a path that reminds us of our common origins in material, thinking, and spirit."

Jesse Bransford, artist, Clinical Associate Professor of Art, NYU Steinhardt, and author of *A Book of Staves*

"For those attempting to incorporate the study of alchemy into the academic curriculum, Brian Cotnoir's *On Alchemy* stands as the ideal sourcebook for both undergraduate and graduate students. Well-organized, clear and concise, this study provides an understandable framework for students of all levels to enter into this notoriously complex and difficult terrain. Because the author has so deeply processed his subject matter, the language flows with elegance and ease, illuminating even the most esoteric of alchemical ideas and processes."

Susan L. Aberth, Edith C. Blum Professor of Art History and Visual Culture, Bard College and author of *The Tarot of Leonora Carrington.*

ON ALCHEMY

ESSENTIAL PRACTICES
AND MAKING ART AS ALCHEMY

BRIAN COTNOIR

ILLUSTRATED BY R JAMIN

WATKINS
1893

On Alchemy
Brian Cotnoir

First published in the UK and USA in 2023 by
Watkins, an imprint of Watkins Media Limited
Unit 11, Shepperton House, 83–93 Shepperton Road
London N1 3DF

enquiries@watkinspublishing.com

Publisher: Fiona Robertson
Assistant Editor: Brittany Willis
Copyeditor: Ingrid Court-Jones
Head of Design: Karen Smith
Design concept: Kieryn Tyler
Illustrations and Cover Design: R Jamin
Illustrations on page 89: *Nesykhonsu Mummy Case*,
Cleveland Museum of Art; *Fayum Man with Sword Belt*,
British Museum; *Christ Pancrator*, St. Catherine's Monastery,
Sinai, Egypt.
Production: Uzma Taj

A CIP record for this book is available from the British Library

ISBN: 978-1-78678-770-5 (Hardback)
ISBN: 978-1-78678-793-4 (eBook)

10 9 8 7 6 5 4 3 2 1

Typeset by Lapiz Digital Services
Printed in the United Kingdom by TJ Books Ltd

www.watkinspublishing.com

for the friends

Table of Contents

Hekate
 of the crossroads,
like Persephone,
 guide us

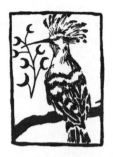

Full Circle

T his is probably the last thing I will write. So, I want to put down as clearly as I possibly can what I have found to be good and useful in the practice of alchemy and, by extension, in creative work and life. I do this in the hope that I will come across this book the next time around and save myself some time getting started again. In the meantime, I believe these are ideas and practices useful for artists and makers who may wish to use their

creating as a way of making change in worlds, both inner and outer.

This book will guide you through the inner alchemical practices such as meditation, visualization, and dream work, while the practical experiments described will ground you in alchemical theory. Most importantly, this book will show you how you can use your art practice as an alchemical practice.

Pared down to the essentials, I give no specific cultural, religious, or mythic framework with which to work except as an example or illustration. Consider these practices as nests in which to structure and imagine your work. I leave it to you to work out the details.

It is all an experimental work in progress, my exploration of alchemy. But what I present here are all true, attested statements. All, if implemented in a practice – any practice – will enhance and charge that practice.

This impulse to compose and re-compose is the alchemical impulse, to want or need to

change, transform, transfigure, or transmute
in an ascent from the imperfect to the perfect,
from ignorance to wisdom – to the betterment
of self, community, and world – this is alchemy,
as this book will show.

Alchemy is the art and science of bringing
something to its final perfection. Your
understanding of this definition will deepen
as you continue reading. To give a complete
historical account of alchemy's development
is not what this book is about. But suffice it
to say that Western alchemy has its more than
2000-year-old roots in Greco Roman alchemy
and the philosophies of Alexandria, Egypt.
Moving from there to Byzantium, it developed
a more philosophical nature and material uses
such as the incendiary weapon "Greek fire" (an
early form of napalm). With the rise of Islam
and its embrace of learning and the sciences,
alchemy evolved further both as a spiritual
quest as well as, or as part of, a material quest –
to know the world of creation is to come closer
to the creator. This is the alchemy that entered
Europe in the 12th century through Andalusia
and Sicily according to textual tradition. There

are indications that alchemical practice – the techniques of alchemy – arrived around the 9th century, as evidenced by the *Mappae Clavicula*, an artist's manual that contains much from the Greco-Roman tradition, particularly from the *Four Books of Pseudo-Democritus*. This tradition continues in the early works of medieval and renaissance art manuals.

Alchemy in the early centuries in the West was mainly focused on transmutation and questions concerning the nature of matter, with some elements of inner aspects. These inner aspects were mostly subsumed into the religious practices, rituals, and prayer of the individual alchemist in question, with the material demonstrations in the laboratory affirming their philosophical and theological worldview. Medicine was the other important branch of alchemy since its inception in Europe, as we see in the medical writings of Arnald of Villanova (c.1240–1311), John of Rupescissa (c.1310–62), and Marsilio Ficino (1433–99). However, it was Paracelsus (1493–1541) who moved alchemy away from its transmutational focus and more firmly toward medicine and

healing. One can consider there to be three significant strands of alchemy that at times intersect with each other – transmutational alchemy, medicinal alchemy, and spiritual alchemy. And along with these three, as with all human endeavors, were the hucksters, cheats, and charlatans, known as the "puffers".

By the 18th century, the pursuit of transmutational alchemy was essentially over. It was ended by two true believers in transmutation – Sir Isaac Newton (1643–1727) and Sir Robert Boyle (1627–91) – the last alchemists and, respectively, the first physicist and first chemist. From this point forward, alchemy's development slowed and fell into disrepute. Or, more accurately, parts of alchemical practice and theory did, but other parts evolved into the more powerful and accurate tools of physics and chemistry that can unlock and make useful the material forces of the world.

And yet, as expressed in alchemy, the sense that the world is based on change and transmutation continued with its strong appeal. In the mid-19th century, one of the first "modern" writings,

A Suggestive Inquiry into the Hermetic Mystery, written by Mary Anne (South) Atwood (1817– 1910) and published in 1850, put aside alchemical transmutational practice and tried to understand alchemy's inner spiritual aspects and intentions. She used ideas current at the time – for example, electricity and magnetism, and the practice of mesmerism from early psychology – to help understand and explain the inner processes.

The heart of Atwood's argument is based on the Neoplatonic framework of the ascent of the soul to the One. Through her deep study of Neoplatonic, Hermetic, and alchemical primary sources, she understood that the alchemist must first ascend to the One, and only after that channel had been opened could the physical work of change and transmutation take place. She is not saying transmutation isn't possible, but that it is only fully realized after union with the One – a side effect of this ascent to the One, if you will. Atwood also suggests that Mesmer's "animal magnetism" can be used to induce the "trance" states mentioned by the Neoplatonists in their practice of the ascent to the One[1] and that it is one of the secrets of alchemy.

✦ ————————————

1 See *Early Magnetism*, ΘΥΟΣ ΜΑΘΟΣ, (ThUOS MAThOS), an anagram for Thomas South and so ascribed to him. However, on close examination, the book appears to be a joint composition of Mary Anne Atwood and Rev. Thomas South, her father.

It is her book that helped to establish the definition and practice of alchemy exclusively as work on the soul and, going forward, it greatly impacted how alchemy was viewed. I believe it was the basis for two turns in alchemy's evolution that, while developing their own interpretations and use, clouded over the deeper aspects of a full alchemical practice (as attested to in Greco-Roman and Islamic practice). One was the late 19th-century Occult Revival's use of alchemical symbolism in ceremonial ritual practice, as we find in the writings of the Hermetic Order of the Golden Dawn.[2] And the other – the psychological interpretations started by Herbert Silberer in his *Problems of Mysticism and its Symbols* and further developed by C G Jung in his psychological model.[3] This is not to say that either of these approaches is wrong. They have skillfully adapted practices or interpretations of alchemical theory aimed toward wisdom and healing, but they obscure a more complete picture by ignoring the alchemical physical practice involved. Regardless of what chemistry or physics considers to be a more accurate description of the world, there is in alchemical

✦ ───────────────

2 See Israel Regardie, "Magical Formulae of Neophyte Grade", *The Golden Dawn*, 6th ed., Llewellyn Publications.
3 See *Secrets of the Golden Flower*, a work on Chinese alchemy by "spirit-writing", and Jung's *Psychology and Religion*, 1938.

thought an engagement with matter and process that may provide some insights into the ways of making changes in the world. What both the occultists and the psychologists missed is that, in a full experience of alchemy, material practice is the *means* by which ascent to the One is accessed. The world as it is, is the entry point in all its churning and display. To better grasp what this physical practice may entail, I have included some essential laboratory practices that are useful and illustrative of alchemical theories and their worldview. They are initial frameworks for practice; their development, however, is up to you.

This book is, in a sense, a workbook. Throughout, there are instructions for both material and meditative practices and exercises. A review of the Table of Contents and a quick flip through the book will give you an idea of what is involved. I recommend reading the book straight through, looking up unfamiliar words and concepts, and making notes or reference marks in the margins if you wish, but don't worry about whether or not you "get it". Just keep going, and when you get to

3 See *Secrets of the Golden Flower*, a work on Chinese alchemy
written by "spirit-writing", and Jung's *Psychology and
Religion*,1938. Herbert Silberer's work first appeared in the
German *Probleme der Mystik und ihrer Symbolik*, 1914.

the end of the book, you'll better understand what came before and how to proceed.

Each chapter gives a grounding in theory, inner practice, material practice, and how it all comes together. But it will only coalesce in this manner if you engage it with mind, eyes, and hands. The way the book is structured – the wide margins, blank note pages, and template at the end is for this purpose.

This book needs you to activate its contents. So, do the exercises, follow the leads, use color, look things up, then add your notes, markers, and diagrams in the margins and in the back of the book. And then, do it again.

Keep going. Keep layering. Keep working. Make it yours. I'll do the same.

The Locus of the Work and the Worker

"There is but one Stone, one Medicine, one Vessel, one Regimen and one successive disposition to the white, and to the red."[1]

Nicholas Flamel

[1] *Nicholas Flamel: His Exposition of the Hieroglyphical Figures*

I n a practice that is both material and spiritual, how, and where exactly, does the work unfold? Alchemy attempts to answer this question by examining the Creation of the Cosmos as the act of the "One". In other words, how does the One become the Many? In the field where the One becomes the Many, we must work within one of the Many to realize the return to the One. The phrase "the One" is usually capitalized to indicate the Monad – the eternal oneness beyond creation and before the creator. However, Arabic and Latin do not capitalize the word[2]. Intentionally or not, this allows for a more open reading of a text, especially in terms of creation. When you encounter the phrase "the One", consider that it could either mean the Macrocosmic Monad or the one of the individual souls in the midst of its own creations.

The *Emerald Tablet*[3], a foundational text of alchemy, describes the act of creation as arising from the One: "The working of wonders is from the one, just as all things came from the one, by a single governance." Here the unity spoken of is the "One" of macrocosmic creation, the

2 The two languages of the earliest versions of the *Emerald Tablet*. Following the Arabic and Latin practice I won't capitalize "the one", instead letting the context suggest the meaning or identity.
3 See Appendix I for the full text and some notes.

source of all "working of wonders", which follows "one governance". At the same time, it can be a creation arising from the individual "one" who, following that single governance, creates "works of wonder". This idea is underscored in the *Emerald Tablet's* penultimate phrase, "Following the creation of the Macrocosm, the Work is completed".

In other words, by following that "single governance", all works of creation unfold regardless of who the creator is or the scale of the creation.

Alchemical practice is both an inner and outer practice, the result of which is the union of these two aspects of practice. To argue which is more important is like asking which eye, left or right, is more important for 3D vision or which one most accurately represents the object of that vision.

By analogy, consider this inner/outer split as two halves of a stereogram (see below) – each one of the pairs of images accurately depicts a scene. In this image there are seven objects

– each image alone tells us something, as do inner alchemy and outer physical alchemy. And each can rest in its own identity.

However, when the two halves of the stereo-gram are fused in the mind, the remarkable experience of 3D vision occurs with the objects floating before our eyes, answering questions neither image alone could answer, perhaps conveying a more profound knowledge. (See Appendix II – How to View a Stereogram).

One of the goals of alchemy is to unify the inner and outer aspects, that is, to see with both eyes. The first step is to recognize the importance of this union and that this union is achieved in the doing.

Allow your intent and creative practices to engage in an anagogic discourse – a discourse on the ascent of the soul. Express your question

through your medium. Then listen. The results of your work will guide you in developing your practice. This is an ongoing process and striving toward this union will become a new basis or ground from which to continue.

What is important to stress here is that any creative act and medium can be used – not just strictly alchemy. Remember, according to the *Emerald Tablet,* all creation follows the same principles, so that any creative act can be used to achieve the inner result.

Alchemy is an embodied practice of psyche and physis, mind and body, engaged and realized through composition. Despite the many small things necessary for any art, there is really only one vessel: the space in which the work unfolds; one matter: artist/medium; and one process: circulation. The artist arises through the art that is made.

The Art of Composition

"Seek out the channel of the soul, from where it descended in a certain order to serve the body; and seek how you will raise it up again to its order by combining action with sacred word... It perfects the soul by means of material powers – that is by means of symbols."

Chaldean Oracle,[1] Fragment 110

[1] Ruth Mayercik, *The Chaldean Oracles: Text, Translation and Commentary*

Alchemy is the Art of arts and the Art of the creative act. It embraces all ways of knowing in bringing some "thing" to its final perfection. This "thing" can be material or immaterial, metal or the soul and its journey to the one. Alchemy enables, through its physical work, the ascent of the soul through the descent into and through matter, an idea and practice I develop in the following chapters.

The geography or cosmography of the soul's journey is vividly described in classical literature, most notably in the "Myth of Er", found in Plato's *Republic*. This is the story (myth) of Er who died in battle and later came back to life and gave a remarkable description of the heavens and the afterlife. In Book VI of Cicero's *Republic*, "The Dream of Scipio", Scipio, the grandson of Scipio Africanus, rises through the planetary spheres and views the Earth and the Cosmos in a dream. Timarchus, in Plutarch's "On the Genius of Socrates", enters the crypt of Typhonius and, after ritual preparations, sleeps and enters a dream where he ascends through the heavens and hears the music of the spheres. And perhaps the most

famous example is Dante in his *Divine Comedy*, where he descends into Hell before his ascent through Purgatory and Paradise.

What the stories have in common is a descent; in the myth of Er, it is death; for Scipio, it is into a dream; Timarchus descends into a tomb for a vision; and for Dante, it was a descent into Hell and an ascent to Paradise. This descent is true of alchemy as well. One seeks out the channel of the soul by working with matter, and this descent is the beginning of the ascent or inner work.

> *"The highest purpose of the priestly art is to ascend to the one, which is supreme master of the whole of multiplicity."*[2]
>
> **Iamblichus**

Theurgy, "god-work", is one of the fundamental roots of the Western esoteric tradition. It is the practical application of Neoplatonic philosophy – the purification and ritual practices involved in the work on the soul and its ascent to, and union with, the one. Traditionally, it uses material methods such as music, geometry,

◆ ———————————

2 Iamblichus, *On the Mysteries*, Book V:22.

ritual, and alchemy to do so. The basic premise of the work is that we need material props or supports to first "activate", the inner abilities for the ascent. These props are physical and conceptual frameworks to help organize and access the connections realized or released through the work. One crucial point in this is that matter isn't an obstacle in alchemy or theurgy but the means by which the ascent – the inner work – begins.

Alchemy starts with the here and now, this physical world we find ourselves immersed in. While my emphasis in this book is on the inner work and how it relates to creative work of any kind, a solid understanding of fundamental alchemical theory and laboratory practices is essential.

Alchemy is built on theories of matter and elements – scientific and philosophical cosmologies established by Plato, Aristotle, and others. These views were generally accepted until the 16th and 17th centuries, when they were challenged by astronomers such as Copernicus. The ancient Greeks' views held that the Cosmos

was Earth-centered in a sequence of planetary spheres, surrounded by a sphere of fixed stars – a bubble nestled in eternity.

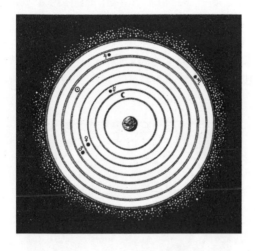

Here is an overview of alchemical matter theories and transmutation. It begins with the sublunary – the area beneath the Moon's orbit – the realm of the Four Elements: Fire, Air, Water, and Earth.

There is a Fifth Element of Space, the Quintessence, within which it all takes place. Fundamental to the Four Elements, according

to Aristotle and accepted by alchemy, are the two Principles: Hot–Cold and Dry–Wet. The interaction of these two Principles gives rise to the Elements, and the alternation or change in Principles causes a change in the Elements. For example, Cold and Wet together give rise to Water. By changing Cold to Hot, Water is changed into Hot and Wet, which produces Air.

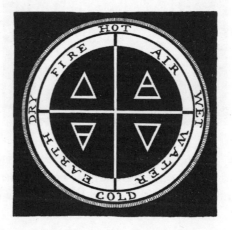

By changing one component of a Principle, the alchemist can change the Elements from one to another.

The Planets also influence these shifting Elements. According to alchemical theory, depending on various factors such as their position relative to Earth and each other, the Planets give rise to the different metals and the powers and virtues of all existent things.

In addition to the Elements, there is a separate system of the Three Principles – Salt/Body, Mercury/Spirit, and Sulphur/Soul – found in early alchemy and again in the medicinal alchemy of Paracelsus.

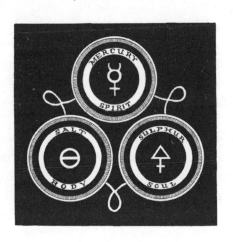

♄ SATURN
 LEAD

♃ JUPITER
 TIN

♂ MARS
 IRON

☉ SUN
 GOLD

♀ VENUS
 COPPER

☿ MERCURY
 MERCURY

☾ MOON
 SILVER

♁ EARTH
 ANTIMONY

This way of describing the components of matter became the dominant arrangement in Western alchemical discourse. Paracelsus states: "Everything that smokes is Mercurius, everything that burns is Sulphur, and the ash is the Sal.[3]" For example, we can identify the Three Principles of any herb; the **Salt** or Body is the mineral salt of the plant found in the ash of the burned plant, the **Sulphur** or the Soul is the particular essential oil of the plant, and the **Mercury** or Spirit is the alcohol (ethanol) that the plant produces during fermentation.

Another key concept is *sympatheia* (Greek, meaning "together feeling"), the observation that one part of the whole affects another because it is interconnected, which is an essential framework in alchemical practice.

> *"In the earth, then, it is possible to see suns and moons terrestrially, but in heaven one can also see celestially all the heavenly plants and stones and animals living intellectually. So, by observing such things and connecting them to the appropriate heavenly beings, the ancient*

[3] *Complete Works of Paracelsus*, Huser edition, vol. 1:74; H6:299–300

wise men brought divine powers into
the region of mortals, attracting them
through likeness. "[4]

On the Priestly Art, Proclus

The connection is through the Quintessence, the fifth essence or element, that is, space. Space is permeated by *pneuma*, sometimes described as a very subtle fire and air, the medium through and by which all things in the cosmos are connected and affect each other, such as tides and the Moon. This quintessence can be alchemically extracted from certain materials, as will be shown later (see page 152).

Although Aristotle stated that the Four Elements existed only beneath the Moon in the world of change and that space was pure Ether, pure Quintessence, various alchemical theories held that the Elements were both below and above the Moon, although in a much more refined state.

This is basically it. This is the cosmology, the language and symbolism of change and making change – the language of alchemy. Understand

✦ ────────────────

4 Proclus, *On the Priestly Art According to The Greeks,* trans
Brian Copenhaver, in *Hermeticism and the Renaissance* ed.
Merkel and Debus, pp.103–5

this and the images used to express these ideas, and you will be on solid ground to read and unpack an alchemical text.

Practically speaking, alchemy takes matter, separates the elements or principles comprising it, purifies the extraneous, and recombines them in proportion, thus transmuting or at least transforming the matter in question. To name this process, Paracelsus coined the term *spagyric* from the Greek – *sparagmos* to tear apart, and *garein* to heap, to pile together. Note that the word *sparagmos* is the same word used to describe what the Maenads, followers of Dionysus, god of wine, did to animals in their frenzy.

Perhaps there are more profound allusions at play here. There is a boyhood story told of Dionysus that, "He rent rams, skins and all, and clove them piecemeal and cast the dead bodies on the ground; and again, with his hands he neatly put their limbs together, and immediately they were alive and browsed on the green pasture."[5]

5 Oppian, *Cynegetica*, trans. A W Mair, (Cambridge: Harvard UP, 1963), p.185

So, there is a tearing apart, a rejoining, and a resurrection. This idea plays out more deeply in the process of winemaking – the grapes are cut and crushed, put into jars to ferment, and the jars are buried. Months later, in Spring, the jars are opened, and the juice is now full of Spirit. Once again, in a very material way, we have a descent and a resurrection. Christianity, for one, takes this further in its stories of wine, blood, spirit, death, and resurrection. From grape to communion – an embodied ascent through descent.

Consider here how all the mythic, theological, natural, and craft aspects intersect in this process, or any alchemical process, and what they have to say about it. It isn't "just" winemaking or "just" a tincture.

Let me outline here, by way of example, the overall process of making a spagyric tincture of an herb.[6]

Using Paracelsus' Three Principles to describe the general process, one first separates by distillation the Soul or Sulphur – the plant's

6 For a more complete explanation and instruction in this work, see Brian Cotnoir, *Practical Alchemy: A Guide to the Great Work*; Robert Bartlett, *Real Alchemy A Primer of Practical Alchemy*; and Manfred Junius, *Spagyrics*.

☿

♁

essential oil. Next, ferment the remaining mass and liquid; this produces the Spirit or Mercury of the plant, which is alcohol. This Spirit is separated and purified through distillation. Then, all the remaining materials, solids, and liquids are reduced, dried, and burned to ash – the ash holds the Body or Salt, the mineral salts of the plant are purified through dissolution, filtration, and crystallization. These purified Principles of Body, Soul, and Spirit are then re-combined, resurrecting the herb in a more "spiritualized" state. This is a "spagyric tincture" of the herb. It is more potent than an ordinary herbal tincture because it includes all Three Principles. The Salt grounds the spiritualized state and makes it more absorbable by the body when ingested.

What I have just described is basically pharmacy. The complete alchemical approach is to consider all the mystic aspects of the herb, as in the wine example above, while "seeing" the whole process in our mind's eye before performing it. And then actually doing the work. By repeatedly working like this, ultimately, you will be able to "see" flawlessly

the whole "process" from beginning to end in all its detail using your inner eye. Once this has been fully internalized, it invigorates the inner work while charging the outer work with a new depth of energy that arises from insight.

> *"Operating in this manner, you will obtain the proper, authentic, and natural tinctures. Make these things until you become perfect in your soul."* [7]

Zosimos, 4th-century
Alexandrian alchemist

[7] Zosimus, *Second Book of The Final Reckoning*, Grecs 3:235-6; *Letters to His Sister Theosebia*: "The Book of Images", p.55.

Essential Practices

"Make these things until you become perfect in your soul."

Zosimos

L et's now turn to the idea of perfecting the soul through the making of things. There is no single work that shows how this is done, where these inner practices of alchemy are given and explained. However, one finds fragments and allusions to them scattered throughout the alchemical literature,

often as a single line of introduction to a topic, as we see here in the 4th century Alexandrian alchemist Zosimos of Panopolis' *Second Book of the Final Reckoning*:

> *"Let your body rest, calm your passions, resist desire, pleasure, anger, sorrow, and the dozen fatalities of death. In thus conducting yourself you will call to you the divine being, and the divine being will come to you, he who is everywhere and nowhere."[1]*

The fragments often reference Hermetic and Neoplatonic texts. The above quote relates to a dialogue between Hermes Trismegistus and his son Tat found in *Corpus Hermeticum* XIII.7. Note the reference to the resting or idling of the body and the senses, and the phrase "dozen fatalities of death". And in the quote below, the twelve "tormentors" are listed:

> *"Leave the senses of the body idle, and the birth of divinity will begin. Cleanse yourself of the irrational torments of matter.*

[1] Zosimus, *Second Book of the Final Reckoning*, Collection Alchimiques Anciens Grecs, 3:235–6.

Do I have tormenters within me?
More than a few, my child; they are
many and frightful.
I am ignorant of them, father.
This ignorance, my child, is the first
torment; the second is grief; the third is
incontinence; the fourth, lust; the fifth,
injustice; the sixth, greed; the seventh,
deceit; the eighth, envy; the ninth,
treachery; the tenth, anger; the eleventh,
recklessness; the twelfth, malice. These
are twelve in number."[2]

They both assert that for the "birth of divinity"
to begin, it is necessary to withdraw from the
senses, to leave them idle[3]. This is a practice
with two components. One component is the
stilling of external stimuli and activity, and
the other is turning the attention inward. This
inward focus sometimes occurs spontaneously
during ordinary activities. For example, while
walking deep in thought, we walk right past
a friend, not "seeing" them. Our attention is
turned inward, and our eyes may be open, but
we don't "see". When practiced with intent in

[2] *Hermetica*, trans. Brian Copenhaver, p.51
[3] We also find these instructions in the practice of yoga. See
The Yoga Sutras of Patanjali. Book II, pp.54, 55

stillness and silence, this turning of the senses inward becomes even more profound:

> *"We must turn our power of apprehension inward, and make it attend to what is there. It is as if someone was expecting to hear a voice which he wanted to hear and withdraw from other sounds and roused his power of hearing to catch what, when it comes, is the best of all sounds which can be heard."*[4]
>
> **Plotinus**

This turning inward isn't so much about denying or cutting off external distractions and temptations of the senses (necessary as that is), as it is about finding the draw of the inner process that is far more interesting than what is going on "outside". Consider how the cat watching the mousehole is not at all interested in the feather you are dangling. Find that quality of attention in yourself.

Fundamentally, it is about developing the ability to place our attention where we want to put it and keep it there. We achieve this

4 Plotinus, *Enneads* V:1.12

ability through the regular daily practice
of meditation.

Meditation

Outlined here is the basic technique – the
mechanics – of meditation.

To begin, find a place where you can sit each
day with minimal distractions. Ideally, try and
do this at the same time and place each day.
This helps establish a daily practice by setting
that time aside specifically for the practice.

Then sit.

If you are sitting in a chair, keep your feet flat on
the floor and place your hands in your lap; this
allows your shoulders to relax. Sit up straight
– do not lean back, do not lean forward – and
find the balance where your spine and head
remain upright with minimal effort. This helps
maintains alertness so you don't fall asleep,
which is important – you need to relax, but not
enough to fall asleep.

If you wish to sit on the floor in a more
traditional posture, it is essential to sit on
a cushion to ease the pressure on the lower
spine. Sit in a comfortable cross-legged
position, as above, with your hands in your
lap, back straight and balanced. Alert but
relaxed. Think of the cat at the mousehole,
sitting calmly but totally alert.

Your eyes are open but gently gazing downward
at a comfortable angle; let them rest on a spot
on the floor a couple of feet away, whatever
feels natural.

To keep this practice at its most basic, use the
breath as the object of meditation – the thing
your mind will focus on is your breath.

Very simply, the practice is just sitting, counting
your breaths.

One cycle consists of an exhale and an inhale –
count ten cycles.

Notice the gentle rise and fall of your breath.
Just watch it. No forced breathing or any effort;

just observe the flow of your breath. Maintain this easy watching of the breath and start to count the breath.

It sounds easy counting ten cycles, doesn't it?

Try it. You will quickly discover how chatty and distracted your mind is. How fast it wants to move on to something else. You will notice that one of two things usually happens; by the fourth breath, your mind is working out shopping lists and has lost all track of the number. Or, as you count your way past the 37th breath, you realize that you were on autopilot.

When you've recognized that you've missed the count, you start over. Repeat the count from 1. When you can make it to 10, do another cycle. It is a practice. And short, consistent daily routine is what is needed to be able to get your mind to stay in one place.

At first, you should sit for 5–15 minutes and extend the time as your body and mind acclimate to this new exercise. As awkward as it may feel and as insignificant as it may

seem, I want to stress that this is the most fundamental of all practices. If we can't put our mind to something and hold it there for something as simple as following the breath, it will be near impossible to work on other far more subtle things that demand much more attention. Think of it this way; your attention is like the light from a candle. To read or study in this light, it needs to be steady and even. A sputtering, flickering candle is a useless light by which to read. So, steadying the light, steadying the mind is the first step to any deeper work.

You can do this with other objects of meditation using the same technique of returning the attention to the object. For example, tracing or rehearsing a process from beginning to end is one such object. Once you are comfortable and have established a relatively steady practice, try following an action from start to end.

The Four Rules of Action

In our day-to-day world, action follows four rules. You can use them in considering any

act or phenomenon. You will find that a deep understanding of cause and effect is crucial for going forward.

> *"Whoever sows wheat only harvests wheat, and if you sow wheat, you do not harvest barley. Cultivate gold and you will harvest gold."*[5]
>
> **Zosimos**

Rule 1: Actions have results

Every action has a result. They may be unintended, but there are results. Reach for the salt and knock a glass to the floor. It shatters. What does it have to do with the salt? Nothing. It's just a clumsy move, and there's glass on the floor.

Rule 2: Results have causes

If there is a result, there must have been an action that gave rise to it. If there is a broken drinking glass on the floor, there are actions that produced it; whether the glass fell to the ground or was placed there by a film crew for the next scene, it doesn't matter. There was an action that produced the result, intended or not.

[5] Zosimos, *Mushaf as-suwar: The Book of Pictures.*

Rule 3: Like comes from like

Oak trees come from acorns, and tigers come from tigers. Maple trees do not produce goats, and chickens don't give birth to vacuum cleaners.

Rule 4: Actions grow and expand

Once an action has started, it continues to ripple outward. Take the example of the broken glass on the floor. Someone barefoot steps on a small piece, cutting themselves; maybe because of this, they are delayed in leaving the apartment or setting up the next scene; perhaps this delay leads to... . You get the idea.

Even though these four rules appear rather obvious, a thorough grasp of them is essential. You achieve this insight by taking an action and its result and slowing down the flow from the impulse to the outcome. Watch how it unfolds from beginning to end. For example, you get to the subway just as the train door closes in your face. Trace your path from locking your apartment door to the closed subway door.[6] What events along that path, if changed, would change the outcome? Play it

✦ ——————————

6 See *Run Lola Run*, 1999. A film that plays with this idea.

forward. Play it backward. Often. Get this idea into your bones until this process becomes an element in your perception and understanding of the world. With practice, one can project the possible results, thereby anticipating problems beforehand. This is crucial in order to move through alchemical experiments and other complex situations with more insight and less physical risk.

> *"We must close our eyes and invoke a new manner of seeing, a wakefulness that is a birthright of us all, though few put it to use."*[7]
>
> **Plotinus**

In practice, one uses the inner eye – the mind's eye. To see creation as a flow from idea, vision, and materials through to the finished piece and its impact on the world is invaluable in maximizing the realization of the creative act.

Practice this as an extension of turning the senses inward. First, to settle your mind and body into the practice, follow your breath as described on page 43. Then shift your attention

◆ ——————————————

7 Plotinus, *Enneads* I: 6, 8.

from your breath to consider an event and trace its development from beginning to end.

Traditionally the theurgists and philosophers recommended geometry[8] to purify the inner eye so that deeper work could continue. Proclus notes this in his *A Commentary on the First Book of Euclid's Elements*:

> *"When 'the eye of the soul' is blinded and corrupted by other concerns, mathematics alone can revive and awaken the soul again to the vision of being, can turn her from images to realities and from darkness to the light of intellect, ... so that she may aspire to bodiless and partless being."[9]*

Geometry began with measurements and divisions of land. These practices were abstracted and moved to "pencil on paper" with straight edge and compass, codified by Euclid and others into the present-day geometry we study in high school. Taking this same high-school geometry, with persistent, consistent practice and exercise, we can internalize the

[8] To do this see: Proclus' *A Commentary on the First Book of Euclid's Elements*, trans. Glenn R Morrow, Princeton,1992. This work has references to the theurgic practice of animating statues scattered throughout. Also see Paul Lockhart's *Measurement*.

rules and procedures of geometry and, in time, easily visualize a solution to any geometry problem. This is the new ground from which great invention and insight arise. Through this, the inner eye is awakened, exercised, and strengthened, enabling it to be used in all aspects of life and the work.

One of the reasons the practice of geometry is so effective is the dual nature of its objects of study. Consider that geometrical objects like triangles, rectangles, and so on, have a strange existence – they are definite yet intangible. Take, for example, an equilateral triangle; save for size, it is the same in everyone's mind and behaves in the same fashion regardless of who, when, or where it is imagined. It is this quality of residing between the concrete and the intangible that makes it useful for developing and purifying the inner eye.

With this practice, the inner eye is purified; problems and questions are easily seen and solved, allowing for more complex problems to come forward; and so the ascent begins. Through these strict rules and definite intangible

9 Proclus, *A Commentary on the First Book of Euclid's Elements,* p.17.

objects, we learn cause and effect and the pathways forward on a deep inner level. And it all happens within. In fact, without proper training in geometry and the resulting ability to see with the mind's eye, the philosophers believed the aspirant would be severely restrained in their spiritual development.

Other Pathways Forward

There are of course other ways to develop our innate ability, such as through visualization. To do so, you must first acknowledge that it is indeed a natural ability that can be developed. You can demonstrate this to yourself with this simple exercise. Think of your work surface – a desk, dresser, kitchen counter – something you engage with daily. Now, describe the arrangement of things on the surface and, as you do so, pay attention to how you know this. You will see that there is a visual sense, a visual memory of sorts, which allows you to do so. This is the basis for visualization. It doesn't need to be a fully robust image in front of your eyes as if it were actually there; even a vague visual sense is a good start. And, like any innate

ability, it can be improved with repetition and exercise. Start small and then slowly extend the practice.

This is why geometry was so valuable in early philosophical practice for purifying the inner eye. That is, removing the distractions and mental noise that keep you from mentally seeing clearly. To develop this ability to visualize, repeat the above simple exercise with different physical spaces you know. You can also use activities or processes you frequently engage in, such as sports, cooking, lab work, ritual, or whatever. Imagine you are doing the activity and rehearse it mentally and visually. By doing this, you strengthen the visual pathways, build more vivid representations, and make the physical enactment more skillful and mindful – a fruitful ground for the inner work to continue evolving.

"Saying these things, I went to sleep."[10]

Zosimos

This rehearsal, this visualization, also plays a role in dream work. The practice of "dream

✦ ———————————

10 Zosimos, *Of Virtue.*

incubation" draws on it. Dream incubation is a method initially used in medicine by the ancient Greeks. An individual seeking help or a cure would enter the temple of a god. After specific ritual preparations, they would pose a question or a problem to the god. Then they would sleep through the night in the expectation of the god's visitation in a dream with a cure or answer. Dream incubation was also engaged whenever one sought guidance or oracle from a god. This is what Timarchus in Plutarch's story did when spending the night in the cave of Typhonius seeking the Genius of Socrates.

There are many examples throughout art, science, and alchemy where dreams offered solutions to a physical problem. Various fields of science all seem to have their stories, but one of the more revealing incidents is the case of Dr. Hermann Hilprecht, Assyriologist at Penn State[11].

For months in 1893, Dr. Hilprecht was at work deciphering a fragment of an agate finger ring excavated from the Temple of Bel at Nippur. One

[11] Other dream stories: Dr. August Kekule and benzene, 1865; Louis Agassiz and fossil fish, 19th century.

night, after long, intense study, he fell asleep and dreamed he was at the temple, and a priest came to him and showed him that the ring was a fragment of a votive cylinder. The cylinder had been cut millennia ago to make earrings for the statue of the god Ninib. Professor Hilprecht awoke, realized the truth of it, and when he had gathered the pieces, he found they fit together perfectly. Once assembled, the inscription reads, "To the god Ninib, son of Bel, his lord, Kurigalzu pontifex of Bel has presented this". It is not that a priest actually visited Dr. Hilprecht, but that in his dream, his mind put together fragments he had intensely studied over the years that were scattered throughout various museums and collections. The intense preparation or attention to the problem is the basis – the "fuel" – for that level of dream work to occur.

The intense preparation involved in this story makes this a good example and shows how through all those years, the mind had been working in the background with all the texts and images studied. And how, in one moment, it all came together in a dream. This is a rather

remarkable ability that we all have – to be able to tap into this treasure house of memory we carry even while we sleep and dream. We may, with intention, develop this into a profound tool for all composition.

We find this idea of preparation or rehearsal in one line in *Of Virtue*[12], another text from Zosimos, who opens the work by first stating the process or problem he is working on:

> *"The composition of waters, the move-ment, growth, removal, and restitution of corporeal nature, the separation of the spirit from the body, and the fixation of the spirit on the body are not due to foreign natures, ..."*

Once he has stated the problem, he reveals the method of dream incubation in the phrase, "Saying these things, I went to sleep", and he then dreams:

> ... *"and I saw a sacrificing priest standing before me at the top of an altar ..."*

12 Zosimos, *Of Virtue*, in *The Alchemy Reader*, Stanton J Linden, p.51.

In the dream that follows he perceives his answer:

> ... *"And while yet he spoke these words to me, and I forced him to speak of it, his eyes became as blood, and he vomited up all his flesh. And I saw him as a mutilated little image of a man, tearing himself with his own teeth and falling away.*
>
> *And being afraid I awoke and thought 'Is this not the situation of the waters?' I believed that I had understood it well."*

Try it; like Zosimos, set an intention or ask a question and saying those things go to sleep. It is a very fruitful process that can yield some good results. There is much to explore with this technique. One possible experiment would be to have several people incubate the same question or problem, compare the answers, and then enact the "collective" solution. This could lead to an alignment of dreams and dreamers to a potent effect.

As you see, using dream incubation to work out problems in the waking world is very useful. It is also used in more theurgic alchemical work

with dreams that allows us to point ever more deeply inward – continuing alchemy's project of ascent through descent.

The same process is used as in the dream incubation of setting intentions, but instead of a problem from the day world, the intent is to awaken within the dream and to exercise the "dream body".

> *"Often when a man is asleep something in his soul tells him that what appears to him is a dream."*
>
> **Aristotle, On Dreams, 462a**

The dream work that allows this is now called "lucid dreaming"– a dream state in which the dreamer is aware and conscious of dreaming and being in a dream. During lucid dreaming, the dreamer can exercise control of the dream and engage with characters and events unfolding. With consistent intent and application, we can all develop this state, which occurs naturally.

To lucid dream, the first step is to start remembering and recording your dreams. This

does two things; one, you might discover you are having lucid dreams and that you're just not recalling them, and the other is that it strengthens your intent to have lucid dreams. As you record your dreams, set your mind to awaken within the dream and remember them. Writing them down on awakening is an excellent way to reinforce dream recall. When you can recall dreams regularly each night, start to set the intention to have a lucid dream as you fall asleep. Tell your mind to recognize that you are dreaming; as your mind drifts from this idea, bring it back with a thought like, "when dreaming, I will recognize that I am dreaming". This should be the last thing on your mind as you fall asleep.

When you awaken from sleep, record your dreams and strengthen your intent to remember you are dreaming during the dreams. During the waking hours, try to see everything as if in a dream. Ask yourself, "Am I dreaming or not?" Don't just say it; try and experience it, have a sense of a dream. By doing this during the day, we are giving ourselves a prompt that may show up in a dream during sleep. At the

very least, it strengthens intent. If you repeat this simple practice nightly and daily, you will soon experience a lucid dream. Again, in all of this, it is patience and persistence that will lead to results. Once you have lucid dreams on a regular basis, start to bring your alchemical or art practice into the lucid dream.

What you work on in the day world generally becomes the focus of the dream world. It is what you will most likely awaken to in the dream. When you find yourself awake in the dream, engage with your work or practice while maintaining awareness. The dream will either give some content useable in the waking world (such as an insight into technique), or sometimes something quite surprising will occur that will guide you inward.

Another thing to bring into the lucid dream is the various instructions found in Hermetic, Neoplatonic, and alchemical texts. For example, when one of these texts says "behold ...", or "consider ...", or "before you ...", it is inviting us to bring to life whatever is being discussed in our mind's eye through

meditation, visualization, and especially lucid dreaming. See this instruction from the *Corpus Hermeticum* where Mind instructs Hermes:

> *"Consider this for yourself: command your soul to travel to India, and it will be there faster than your command. Command it to cross over to the ocean, and again it will quickly be there, not as having passed from place to place but simply as being there. Command it even to fly up to heaven, and it will not lack wings. Nothing will hinder it, not the fire of the sun, nor the aether, nor the swirl nor the bodies of the other stars. Cutting through them all, it will fly to the utmost body. But if you wish to break through the universe itself and look upon the things outside (if, indeed, there is anything outside the cosmos), it is within your power."*[13]

Remember, this is not so much about the interpretation of the dream but about accessing the mind supporting it and developing those channels to reach the source of the dream,

[13] *Corpus Hermeticum*, XI, 19, trans. Brian Copenhaver

and to push beyond. It is not the letter and the meaning of its contents that we search for here but the sender, so to speak. The *Corpus Hermeticum* continues:

> "Make yourself grow to immeasurable immensity, outleap all body, outstrip all time, become eternity and you will understand god. Having conceived that nothing is impossible to you, consider yourself immortal and able to understand everything, all art, all learning, the temper of every living thing. Go higher than every height and lower than every depth. Collect in yourself all the sensations of what has been made, of fire and water, dry and wet; be everywhere at once, on land, in the sea, in heaven; be not yet born, be in the womb, be young, old, dead, beyond death. And when you have understood all these at once – times, places, things, qualities, quantities – then you can understand god."[14]

Do these things when in a lucid dream. Doing so exercises the "dream body", and with it will come

[14] *Ibid.*, XI 20

realizations of the nature and operation of being and consciousness. This is what an alchemical dream enables; it points the way through the lunar realm, through the tidal pools, past the coral reefs, and into the silent deep:

> ... *"if you wish to break through the universe itself and look upon the things outside (if, indeed, there is anything outside the cosmos), it is within your power."*[15]

For this discourse not to lead you astray and to guard against self-deception and inattention, understand that ethics are essential. They are something that are stressed in all texts and are of significant importance. They are perhaps the hardest of the inner practices:

> *"But let not him who desires this knowledge for the purpose of procuring wealth and pleasure think that he will ever attain to it. Therefore, let your mind and thoughts be turned away from all things earthly, and, as it were, created anew, and consecrated to God*

◆ ───────────────

15 *Ibid.*, XI 19

alone. For you should observe that these three, body, soul, and spirit, must work together in harmony if you are to bring your study of this Art to a prosperous issue, for unless the mind and heart of a man be governed by the same law which develops the whole work, such a one must indubitably err in the Art."[16]

The Sophic Hydrolith

Take what you know about action and now consider those living around you in space; family, friends, colleagues, community, and so on, and time; those around you now, those generations to come, and those before. And ask, does the action undertaken create a plus overall? Who does it really impact, and how? This is critically important if you are doing any physical lab work with toxic materials and fumes. Think the process through and prepare for breakdowns big and small in the system because they will happen. The more intense and intentional the act, the more energy there is for it to endure and ripple out for good or bad. Aim your work toward healing and wisdom with attention and intent, and you should be fine. The emphasis is

[16] The Sophic Hydrolith, *The Hermetic Museum*, p.76.

on *should*, as we may be unaware of the many factors in play. Remember that all actions have results, regardless of how small or insignificant they may appear.

If you decide to go deep with this practice, remember that solitude and silence will be your first companions.

> *"In the moment when you have nothing to say about it, you will see it, for the knowledge of it is divine silence and suppression of all the senses."[17]*

> **Corpus Hermeticum**

Like anything else in the world, these exercises require persistent practice for results to accrue. One way to do this is to commit to making it happen. Start small and build. For example, find a quiet place and sit for 5 minutes each day, and attach it to something you do every day, like brushing your teeth in the morning. Do that and then sit for 5 minutes, settle your mind and body by following the breath for a few cycles and then do any of the exercises. For example, take an action and follow it from its beginning

✦ ———————————

17 *Corpus Hermeticum*. X:5, trans. Brian Copenhaver

to its result; or mentally rehearse a process; or do a simple visualization of objects on your desk. But sit quietly and alone to do this, claim this space and silence, and gently extend the duration over time. Then clothe these, if you will, with the icons of your practice.

External solitude and silence should lead you to develop an inner solitude and silence, the point zero of movement and change. This silence within, when deepened, can abide any onslaught of noise and chaos. Find this, let it grow, and you will never be thrown. Any situation, good or bad, from the perspective of this deep silence becomes a possible pivot point for change – for transmutation – and can be used as such.

As you begin, there will be a quick accumulation of knowledge and technique. It will all feel very good, almost exhilarating, as new insights build and reveal themselves to you, and you gain new skills. At some point, this rapid ascent will slow and plateau. Things will flatten into a long slog of work. The excitement and thrill are replaced with endless repetition and chores. Those only looking for the novel begin to lose

interest and drift away at this point. But this is the very moment when the work starts. It may feel boring, but this is simply the surface beneath which you are consolidating your knowledge and experience. Do not disrupt it by shifting attention or direction and filling that "bored emptiness" with noise and distraction. "Boredom" is, in reality, an infinite well of creativity if you have the energy to endure it.

> *"Operating in this manner you will obtain the proper, authentic, and natural tinctures. Make these things until you become perfect in your soul. But, when you recognize that you have arrived at perfection, then beware of the intervention of the natural elements of the material: descending toward the Shepard, and plunging into meditation, you will thus re-ascend to your origin."*[18]

18 Zosimus, *Second Book of the Final Reckoning*, in Berthelot, *Collection des ancien alchimistes grecs*, Vol. 3, pp. 235–6.

Stages and Stations

*"If the two do not become one – that is,
if the volatile are not combined with the
fixed, nothing expected will take place.
If you do not whiten and the two do not
become three, with white sulphur, which
whitens, nothing will take place which
is expected. But when you yellow, three
becomes four, for you yellow with yellow*

sulphur. Finally, when one tints into violet, all the materials join together in unity/Violet."[1]

Maria the Prophetess, 1ˢᵗ century AD

Alchemical change proceeds in stages that, like all change, unfold like the seasons. At each stage of the process, the matter being worked on undergoes a specific color change. The stages are named after those colors – Black, White, Red, and Violet. This sequence comes from some particular protocols of Alexandrian alchemy; however, as alchemy evolved, the color sequence changed as well. Depending on the process and materials, the number of stages and the colors expressed vary. This is to be expected as interpretations of what materials to use in the work change, and perhaps there is a more discerning observation of the color changes as well. The thing to note is that these descriptive color names point to actual color changes observed in the work. And since the changes occurring in the flask also occur or resonate within the alchemist, the color comes to symbolize or express both the deep change occurring in the prima

[1] Zosimos, "On the Body of Magnesia and on its Treatment", III, XXVIII, 9; in Berthelot, *Collection des ancien alchimistes grecs*, Vol. 2, p.192

materia and the awakening in the alchemist/ artist themself.

To begin, you should start the work in silence and stillness – the matter to be worked on is before you. And with your mind's eye, you see the beginning of the work concretely, the frame within which the work unfolds, as well as its end – the perfected object silent in its impossibility. And between these two points of being are all the stages necessary for completion. This is Theoria, a "seeing" both active and projective as well as adaptive and receptive.

The matter is prepared, and the first stage, the **Black**, is one of decomposition, decay, the dissolution into the first matter, the beginning. This stage is one of breaking down borders, structures, an overall deconstruction into its elements. As an inner experience, it is often mistakenly equated with depression. There is indeed a breakdown, and depression may come from mishandling this stage, but mystically it is the "dark night of the soul".[2] This is not despair or depression – it is leaving behind all the old and familiar, comfortable constraints.

◆ ————————————————

2 See St. John of the Cross, *The Dark Night of the Soul*

However, the journey to the new has only just begun. Imagine you have fallen in love, and to reach that love, to realize that love, you gave up all the old comfortable garbage that was immobilizing you, and you left the old behind. And there you are, 3am in a strange land waiting on a cold dark platform for the connecting train. No clocks, no readable schedule, just an anxious waiting. Is it all a big mistake? Wondering, fearing, hoping. There's no going back. Yet, no word from the beloved. But still, you keep the faith regardless of the absence of any sign.

This is a very dark, lonely, frightening place, but it is not depression. Or, more accurately, depression may come out of this if you enter this stage unprepared. When you still hold on to the past, the leap to the next is compromised, and this can lead to a sinking and a disconnect with what was to come while having severed yourself from what was – but not entirely. However, when you enter into this more prepared, you find that all becomes possible in this dissolution. What was locked

up is now beginning to open, and the basis for a new arrangement arises.

Eventually, this stage gives way to the White stage, just as the cold and dry of Fall gives way to the cold and wet of Winter.

White is the stage in which the extraneous is removed and what remains is opened and re-aligned, matter at its most open, like a crystal as it becomes the new structure, nest, or framework. As Hermes Trismegistus says, "If you see the All becoming ash, know that it has been well prepared. For the ash is full of power and virtue". This is the endpoint of the Black stage, the end of decomposition. It is like the blanching of the bones after the body has decayed or the impurities burned away as in calcination, such as in the death of Achilles recounted in the Odyssey:

> *"At last Hephaestus' flame consumed your flesh.*
> *When morning came, we gathered your white bones,*

Achilles, and anointed them with oil
and unmixed wine. Your mother gave
 an urn
of gold with double handles, which
 she said
Hephaestus made and Dionysus gave her.
Your white bones lay inside it, Lord
 Achilles,
mixed with the bones of your dead friend
 Patroclus."[3]

With this, the Black and White stages are completed, and the matter is opened so that the new and resurrected may take shape. The cold and wet of Winter melt into the warm and wet of Spring.

In some processes, between the Black stage and the White stage or between the White stage and the Red Stage, there is an intermediate stage of many colors often called the Peacock stage due to the iridescent and shifting colors seen in the flask. Sir Isaac Newton writes:

"I have in the fire manifold glasses
with gold and mercury. They grow in

[3] Homer, *Odyssey*, BK 24 71–8, trans. Emily Wilson. Greek and Roman myth were considered alchemical allegories in the Middle Ages and the Renaissance, and you need a familiarity with myth is needed to better understand alchemy. Homer's *Odyssey* and Ovid's *Metamorphoses* are the most referenced.

> *these glasses in the form of a tree, and by continued circulation the trees are dissolved again into new mercury. ...*
>
> *For it makes gold begin to swell, to be swollen, and to putrefy, and also to spring forth sprouts and branches, changing colors daily, the appearance of which fascinate me every day.*"[4]

Red is the growth and ripening of the transmuted being – metal or soul. The seed planted in the purified earth germinates and grows, the warm and wet maturing into the red and gold fruits of late Summer.

It should be noted that in early alchemy, metal was defined by color and weight. In other words, if alchemical work produces a metal with the same color and weight as gold, then the metal is gold. And it is at this point that the matter has been perfected – Lead into Gold. And with the next stage what was perfected is now itself able to perfect.

This is the **Violet** stage, named after the purple powder of projection, commonly known as the

◆ ————————————

[4] Isaac Newto*n, The Key*, quoted in B J Dobbs, *The Foundations of Newton's Alchemy*, p.178

philosopher's stone, capable of transmutation. Violet and Purple are colors associated with royalty and celestial powers and, with their appearance, the King has been reborn and empowered to make changes. The perfected matter in its new form is now itself able to reach out and transform. The warm and dry of Summer cools into the dryness of Fall, and the fruit releases its seed.

These last two stages are often referred to as the Yellow and the Red stages, respectively, and are most likely due to a variation of the materials and methods used, since gold in its various states may appear yellow, red, or violet.

These are the stages of change that the prima materia undergoes. And when we consider it as an organic growth, we recognize the seed, the plant, the flowers, and the fruit. Keep this image in mind when working out the links between the outer nature of your own work and the stages of the inner work, much of which you will discover through your attempts to find those links. A good place to start is to

examine your own inner "spiritual" practices that you are engaged in. There are invariably stages, markers of progress in any practice. Identify them, even provisionally. Then find the stages in your material work and, through meditation, allow the "links" between the two to find themselves and to connect.

Look at images of alchemical sequences as depicted in the *Rosarium Philosophorum* (Appendix III). An excellent method by which to study them is to copy them and allow a dialogue to develop among the observations, considerations, and performance. I discuss this method in Chapter 7.

Here now, in the most general of terms, are the apparent stages of the inner process of engagement between intent and performance/ execution. The first stage is *clarity of purpose* in both process and result. *Know the process*, that is, mentally rehearse and visualize it from beginning to end. See the end in the beginning, all at once. This is *Theoria*, as defined earlier (see page 73).

Then, *perform the process*. That is, whatever the thing being worked on, cycle between visualizing the process and enactment of the process. The enacting and embodiment give a material visceral basis for visualizing, thus strengthening your ability to visualize. A more robust visualization makes the material process more transparent and likely to provoke insight and discovery. As Louis Pasteur observed, "chance favors the prepared mind". This is an aspect where the outer stages are linked to or connected with the inner stages. And as mentioned earlier (see page 65), the changes will begin to show in dreams, in the work, and in the world, especially with a prepared mind.

At some point in the work, the material starts to push back and may seem to point out another direction. Be open to exploring this new direction as it will help you develop your own further questions and protocols, your own innovations and experiments – maybe to the point of a new intent, a new process.

What is important to emphasize here is that all of this work is done within the framework of

the more significant questions of "What am I doing?" and "Why?"

These two questions are the most important ones to ask yourself. Regardless of the intent, clarity of your intent is crucial – it is the pole star by which your exploration is guided. And remember that this all takes place with an awareness of cause and effect and within the context of ethics and accountability.

Realize also, as you work your way deeper into the world through this cycling, that you also go deeper within toward the center like in a maze.

Secrets of the Maze
(or another way of looking at it)

In the word **VITRIOL** is found a way.

Visita Interiora Terrae Rectificando Invenies
Occultum Lapidem.

Visit the Interior of the Earth Rectifying
Discover the Hidden Stone.

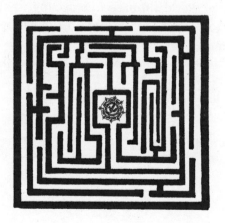

To make your way to this center, you should
work it like a maze – as you work your way
from the periphery to the center, also work
from the center out.

Move from both ends – the start and the finish.

Take the goal as the path.

> *"Where ask is have, where seek is find,*
> *Where knock is open wide."*[5]

Christopher Smart

[5] Christopher Smart, "Song to David" (*Jubilate Agno*
Fragment B)

Image, Theurgy, and Alchemical Practice

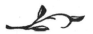

"Do not abuse matter, for it is not dishonorable."[1]

St. John of Damascus

[1] St. John of Damascus, *Three Treatises on the Divine Images*, Treatise 1. 16

Matter is not the enemy. It is the means and basis of one's ascent to the one. Just as any material or conceptual formation can block or distort this ascent, they can also be used to work toward that goal. The Byzantine Orthodox Christian tradition of iconography – the "writing" of icons, the writing of a narrative in images – is a tradition that is a living example of how, like alchemy, the materials and techniques of art might be engaged in this inner ascent. In fact, the study of iconography and Neoplatonism will significantly enhance an understanding of alchemical theory and practice.

> *"The theurgic art in many cases links together stones, plants, animals, aromatic substances, and other such things that are sacred, perfect and god like, and then from all these composes an integrated and pure receptacle."[2]*
>
> **Iamblichus**

An icon, from the Greek *eikon*, meaning image, is a representation that is "ensouled", animated with the spirit of the depicted holy being.

[2] Iamblichus, *On the Mysteries*, Book V.23

It broadly refers to images composed of any material imbued with anima/pneuma, breath, or soul. This idea and practice appear to have origins in the Neoplatonic practice of the animation of statues, earlier Greco-Egyptian practices and beliefs, and perhaps even an ancient Egyptian origin. Consider the evolution of the Fayum Portraits, late Greco-Roman coffin portraits that are a direct descendant of Egyptian mummy portraits and a precursor to the holy icons of Orthodox Christianity.

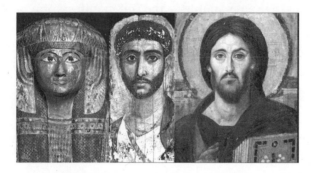

Iconography's approach to matter is no different than Iamblichus'. In *On the Mysteries*, Iamblichus works with all forms of matter as expressions of immanent divinity scattered throughout all aspects of creation,

"like images of the sun in drops of water".[3] So, where Neoplatonism engages with all matter, Orthodox Christianity centers the material work on the body of Christ. Thus, the human body, being the most evolved form of matter, when redeemed makes Christ the most perfect icon. For Iamblichus, bringing together materials under certain conditions and circumstances activates the soul and moves it toward the one. For Orthodox Christians, the body of Christ and its image in icons operates in the same manner – the full manifestation of God in the human body. The Incarnation and the subsequent Resurrection are the heart of Christianity and represent it in images which, because of the Bible's injunction against "graven images", led to questions of idolatry – that is, the danger that the images themselves would be worshipped. And so, on this basis, icons were attacked in the 8th century and vigorously defended. Part of the defense of icons at that time was the argument that, as Christ was incarnate to lead us to God, so holy images of Christ, the Holy Family, Saints, and so on are therefore good and are not idolatrous, but they serve as a link, just as Christ is a link

[3] Plutarch, *Isis and Osiris*, 381a.

– a material assist to the human mind and soul in its movement to God.[4]

> *"An icon of god is the human being who has transformed himself to the image of God, and especially the one who has received the dwelling of the Holy Spirit."*[5]

Pseudo-Leontios of Neopolis, 8ᵗʰ century

The symbolic representations are not only rooted in the image, but the icon is in itself a material representation of the spiritual ascent. The icon in its construction has many layers of pigment; it is, in fact, a pyramid built up from dark to light. It begins with the use of earth tones from minerals such as hematite and ochres on the base layers and builds layer upon layer, and with each subsequent layer the pigments used are more and more refined, ending with gemstones like malachite, azurite, and lapis lazuli as the final layer. Each layer is an articulation of light rising out of the dark chaos.

We find the idea of ascent even in preparing and using the pigments. For example, take a mineral, malachite – a green stone used in jewelry and

4 See St. John of Damascus' *On the Divine Images*.

5 In *Icons and the Liturgy, East and West,* ed. N Denysenko, Notre Dame Press, Notre Dame (IN), 2017, p.64.

with other decorative uses. To prepare it as a pigment, you take the raw mineral, crush it, and grind it, washing the powder with water. After further washing and preparation, the pigment is ready for use. This pigment is then used to create a form on a surface. Then, with other forms and pigments, shapes take place in relationship to each other, the surface, and the viewer. Some forms are soon seen as characters, buildings, or landscapes, and these, in relation to each other, form a narrative, a story. When you see an icon or any image, you are unaware of the various stones from which it arises. But they are there. This journey from mineral to narrative is another example of "from the concrete, to the abstract, to the authentic", the core of Neoplatonic philosophy and practice, and this awareness should be brought into an alchemical or art practice.

The writing of an icon results in the physical object of an icon, just as the practice of alchemy results in a transmuted object. However, through this work, they both can transform the one engaged in the work into an "icon of god".

Iconography's view of the Creation is as follows.[6] The first stage is Chaos, followed by the material universe, the Cosmos; Anthropos – humanity arises next; through its perfection, the universe of God, Theocosmos, follows; and the last stage you come to is Prosopon, the "face" of divine being. And so, the ascent from formless being to being of light is completed.

The stages and materials of iconographic practice are considered symbolically in relation to Creation.

The Board, firm and stable represents the stability of one's faith – it also stands for the Cross. The Linen used in covering the Board as part of its support is the Shroud of Jesus, and the Gesso (primer for the paint) is the emptiness with which we approach God – Theoria. The image is then Drawn and Engraved; this is the image of God on the soul. Next, Red Clay is laid down and Gilded – symbolizing Adam and the breath of God. This is followed by "Roskrysh" – the opening chaos of elements and matter, but no light. It is the first layer of dark pigment, formless filling in the contours of the engraving.

✦ ————————————

6 This is the symbolism as taught in studios of the Prosopon School of Iconology.

This stage represents Chaos, the elements before they were arranged into the Cosmos. The First Lines is a reestablishment of the lines drawn at the beginning of the process to create an icon. It represents order arising from Chaos. Next is First Light; the first layer of lighter pigments is applied, and the move from dark chaos to light and form begins. There are no shadows; this is a light from within. The First Float, a semi-transparent layer, represents the softening or washing away of flaws and errors. The Second Light is applied – it indicates the Anthropos – the movement through Christ to the new Adam "man redeemed". The Second Float, like the first, washes over the errors. The Theocosmos is next symbolized by laying in the Third Light. These small points of light represent light from God. The Third Float removes all remaining blemishes and imperfections. The lines are redrawn, articulating God's face toward the world – Prosopon. Finally, White Lines representing the Uncreated Light are added. And then, most importantly, the Name of the Holy Being depicted is added. It is through this naming that the image becomes an icon. It is then oiled with linseed oil, which unifies all the

layers visually and represents the Anointing. It is consecrated – the image is united with its prototype – and is then ready for Contemplation.

In Orthodox Christian practice, the icon is both a mirror into our souls and a window onto the divine. The icon, its ideal, and canon as a window shows us the goal – the spiritual station we wish to attain, necessary in our journey to the one. The icon is also the mirror by which we see ourselves as we work on ourselves. Each float, light, and detail expresses our inner state and is reflected in the image, which itself becomes a guide as we move from station to station. For example, only through activation by the breath can gold adhere to the gilding clay base. One bends over the clay surface that is to be gilded, hovering very close to the surface; mouth open, one exhales; the humidity and heat activate the clay readying it to receive the gold leaf. Clay (Adam/body), breath (pneuma/soul), gold (the Divine). How well the gold adheres or does not adhere to the clay is not only a question of mechanical technique but is, more importantly, reflective of your soul's disposition.

All aspects of icon writing reveal this way because when we "write" the icon, we are as much inscribing the state of our soul as we are "writing" in images of the story of Christ or a Saint.

And the difference and distance between the window and the mirror reflect the pain of our injustices and iniquities. And it is this discomfort that leads us deeper into our inner practices and equally into the streets to create greater justice and benefit for our community and our world.

> *"No truth in the common assertion that evil is inherent in matter qua matter, since matter too has a share in the cosmos, in beauty and form."[7]*
>
> **Dionysus the Aeropagite**

7 Dionysus the Aeropagite, *The Divine Names*, in *Pseudo-Dionysus: The Complete Works*, p.120.

On Asking and the Observation of the Small

"What we observe is not nature in itself but nature exposed to our method of questioning."[1]

Werner Heisenberg

[1] Werner Heisenberg, *Physics and Philosophy*, Harpers, New York, 1958, p.58.

Observation is a way of seeing. It is the act of seeing and noting the relationship of the parts to each other and the whole, as well as to the full context in which it all unfolds individually and as sub-aggregates and wholes. To observe is to build detail upon detail in a dynamic way. Minor variations or deviations from the expected catch the eye of the sensitive observer and may indicate a set of deeper relations that may lead to a more profound insight into the nature of the world and the project at hand.

Let's take an example. If you stretch a string of a definite length and pluck it, it makes a sound. If you divide that same string in half and pluck one side of it, it sounds the octave. This is true anywhere in the cosmos where there are ears to hear and a mind to perceive – the 2:1 ratio sounds an octave, 3:2 sounds the Fifth, and 4:3 sounds the Fourth.

Big deal. So, what.

It is a small and trivial observation.

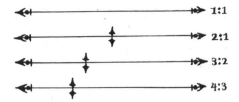

Small, yes. Trivial? Not if you consider that it reveals that there is a correlation between number and physical phenomena and sensation. And that this very observation and conclusion made by Pythagoras (c.570–c.490 BC) is the very foundation of all science.

Or consider the obsession of Johannes Kepler (1571–1630) with the nearly 5-degree discrepancy in the orbit of Mars established from the data observed meticulously by Tycho Brahe (1546–1601). In essence, the issue was that if the orbit of Mars was a perfect circle as all the planetary orbits were considered to be at that time, then why was there a difference of 5 degrees between what the perfect circle predicted and what was actually observed? It was this small detail that led to Kepler's recognition that planetary orbits aren't perfect circles but ellipses – a truly revolutionary insight that has

enabled satellite systems and interplanetary travel. The examples are endless as this mechanism of discovery and invention allows our understanding of the cosmos to evolve.

Observational Practice and Exercise

Observation is a skill that can be developed and enhanced through the practice of drawing. It is a process that demands we commit to making concrete what we see, either through statements or images. To mark the detail strengthens the eye, hand, and mind dynamic, enhancing the "seeing" and observing.

To begin, find a small ordinary object, maybe something organic, like a seed pod, a whole mushroom, or even a set of keys. Something like that. Make your drawing/observation with an ordinary pencil in the margins of a notebook you use for something else, or even the margins here. This arrangement and way of proceeding help prevent the exercise from becoming about making "art". What is essential is that the details are somehow "correct". Not necessarily nicely rendered but

correct in that the particulars draw point to a part observed.

Now look carefully at the object and note its contours. Start by drawing the overall outline. Go back and look very carefully at the object, pick out a detail, and add it to the sketch, erasing and adjusting if necessary. It may be a slow process, but by going back and forth – noting detail, marking detail, and adjusting detail – you will eventually have observed the object through the process of drawing.

Do this often with various small objects and extend that quality of seeing and observing into the world around you. Of course, this doesn't need to be a small object; it can be a view from your window or a corner of the room. It is the process that matters in this observation exercise.

To turn this from an exercise to a means of study, you must bring other areas of knowledge or experience into practice. For example, in observing/drawing a mushroom, knowing its anatomy, the function of its parts,

its environment, its lifecycle, and its cultural meanings and ramifications all deepen the observation, which in turn grounds the knowledge through drawing.

Going further, you can use this method of observation as a way to study and meditate on alchemical images, as mentioned earlier (see page 46). However, this practice differs in that you allow the image you are creating to "push back", which creates a dialogue that opens up the meaning. This is done by drawing the same image multiple times. The first few renderings should be as accurate as possible, and as you make the drawings consider the meanings or references the image has. Continue in this way and, at some point, shifts in the image may occur. Allow them to happen. This is what I mean by "allow the image to push back", and this "push back" is the beginning of a dialogue with this image, this symbol that has, in some small way, come alive. And at the same time, the "icon" is inscribed in one's mind by activating the various pathways among hand, eye, and mind.

At some point, consider pushing this process further by taking one of the alchemical images and working with it as the icon writing described earlier (see pages 88–96). Feel free to explore pigment preparation[2], the layering involved in building an icon, and the symbolism involved. Then, take this process of "iconographic dialogue" and bring it into your own creative work.

Alchemical Observations and Experiments

Ultimately the idea behind the "art" practices described above is to develop your ability to observe and visualize while researching and performing alchemical processes. Outlined here are a few observations that demonstrate some of the essential alchemical techniques – not all, just a few of them to get started and to illustrate some of the theories involved. This work is simple and uses things found in kitchen supply or hardware stores. Once you understand the principles, it is easy to improvise and make improvements.[3] Keep in mind when working through the following observations

◆ ————————————

[2] For methods of traditional pigment preparation, see Michael Price, *Renaissance Mysteries, Vol.1, Natural Color*.
[3] See Brian Cotnoir, *Practical Alchemy: A Guide to the Great Work*.

and experiments that the consideration of the small and seemingly insignificant is key to this work. In fact, the main point of these exercises is in the observation and understanding of what is happening in the process. Material and technique are secondary. As simple or simplistic as these observations may seem – actually do them.

Observation and Experiment #1
Part 1: Calcination – Releasing the Salt

Take some hardwood – oak is good. Grapevine, although not a hardwood, is also excellent. I have suggested these due to their mythic associations and the quantity of potassium carbonate present, but any natural wood will do.

Find a fireplace and watch it burn, tending it until it all burns out, and only ash remains.

Alchemically speaking, Fire is being released from the wood, Air and Water as well, mainly leaving Earth behind. This is the Body.

> *"Hear what Hermes says, 'If you see the All becoming ash, know that it has*

been well prepared. For the ash is full of power and virtue."[4]

<div align="center">

Stephanos of Alexandria

</div>

Observation and Experiment #1
Part 2: Crystallization – Purifying the Body

To further purify the Body/Salt, it must be separated from the *caput mortuum* (deadhead, the insoluble material).

To do this, take the ash and dissolve it in 3–4 times the amount of water or more.

Strain and filter the ash water and set the filtrate aside to evaporate. Depending on the conditions, crystals will form, or an amorphous salt will crust over as the water evaporates. Both are the same Salt differing only in form, and both are the purified Body or Salt of the oak or vine.

Repeated calcination and crystallization will increase the purity of the Salt. Chemically speaking, this is Potassium Carbonate, K_2CO_3. You may use this method to obtain the Salt of any plant.

✦ ——————————————

[4] Stephanos of Alexandria Lecture III, "The Alchemical Works of Stephanos of Alexandria", trans. F Sherwood Taylor, *Ambix. Vol 2. No. 1.* 116–139.

Observation and experiment #2: Circulation of the Elements

Take a pot and fill it with water and heat it. Watch it as it begins to steam and then boil. Now take a dry bowl with ice in it and hold it over the steam. You will see water condense on the underside of the chilled bowl.

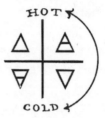

What is happening according to alchemical theory is that Water, Cold + Wet, when heated changes from Cold + Wet to Hot + Wet – that is, Air.

Taking heat from Air returns it to Water.

This is the basis for circulation and distillation.

Observation and experiment #3: Circulation

The most straightforward demonstration is to take that same bowl of ice (see above) and hold it over the steam of the boiling water. Now, watch how water builds up on the underside of the bowl and eventually drips back into the boiling pot. What's happening is that the water below rises as steam; when it contacts the cold surface of the bowl, it condenses the vapor to water, and this water drips back into the pot. This is one cycle.

Understanding this process, you may circulate any liquid. And with this understanding, when you find yourself by the seaside, consider the clouds.

Observation and experiment #4: Distillation

By adding a cup between the chilled bowl and the boiling water (see above), you can collect the drops of distilled water as they fall. A more convenient method is to use a tea kettle to boil the water and hold the bowl over the steam coming out of the spout. This is the mechanics of distillation. It allows us to separate liquids by exploiting the different boiling points of the fluids involved.

The three techniques of Calcination, Circulation, and Distillation, outlined in Exercises 1–4, are fundamental to alchemy. There are others as well but start with these and consider your observations large and small, both here and in the world, recognizing that circulation is alchemy.

For further instructions on making a simple classic circulation and distillation apparatus and how to use it for distilling and circulation, see Appendix 4 of this book.

Observation and experiment #5: The Empty Cup – a Meditation

Here is a meditation on how to open an object and perform an alchemical dissolution.

First, read through this process, *re-read it*, then actually do it. It may seem difficult but take it slow, results come with repeated practice.

The sequence shown here is a series of magnifications from the physical surface appearance of an entity – here a cup – through its gross structures, compounds, molecules, atoms, sub-atomic particles, and so on, to its "final" energy gradient.[5]

Using the illustration of the cup depicted here as a guide to the stages, select an object that's in view when you look up from this page.

✦ ————————————

5 See *Powers of Ten*, a short film by Charles and Ray Eames for another view of this.

Take it slow, and imagine you are entering into this object to see what is there.

In your mind's eye, "zoom in" to a very close-up view of the object and the surrounding air – you can see the details of the ceramic and grains of clay, and so on.

Focus in even closer to the cellular level and note the micro-structures.

Choose a part and go in closer still to the molecular level.

Now imagine you are going deeper into the atomic level, and space is what you see.

Keep going down to the sub-atomic "particles". Here is pure energy, and any differences are very subtle energy gradients.

Let the visualization develop and then stabilize. Strengthen it by cycling through it several times.

Then on the last cycle, lift your eyes and look at the object you've just analyzed. The moment

in which the absence of qualities changes to the establishment of an identity is the moment of discrimination, of naming, the moment of symbolization.

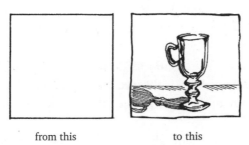

from this to this

Here is a pivot point where change becomes possible

This is a daily meditation that you can and should do anywhere, anytime, with any object of your choosing.

Observation and experiment #6:
The Quintessence of Wine – a Meditation

As preparation for this experiment, read and study the full text of the *Emerald Tablet* (Appendix I) and review all the ideas presented in this book, do as many as possible and then carry out this experiment.

Take red wine and following the instructions in Appendix 4, distill and re-distill it 6 to 7 times. The final distillate is a very concentrated Spirit of Wine often called *Aqua Ardens*, burning water, or *Aqua Vitae*[6]. Place this *Aqua Ardens* in the circulation apparatus and start the process.

And as it circulates and evolves into the Quintessence, observe the process and ruminate on the words of the *Emerald Tablet*.

The work will show you the way forward; this statement is both practical and mystical. Consider how in our art practice, ideas and concepts arise that indicate a new direction or avenue to explore and develop. Then do it.

Some Final Thoughts

And that is that. Really.

What I presented here are the root essentials of alchemy. Anything not articulated here can be developed through your engagement with these first principles and practices and your continued reading and studies.

[6] Note that the Mercury, i.e., alcohol or ethanol, is the same across the plant world. So, as an alternative to distilling alcohol, you can use commercially prepared ethanol of 95 per cent.

And again, I ask the biggest question in all of this, why?

What is your intent?

I posed this question in the section on ethics, but here the question is posed in the larger framework of your life and what you hope to accomplish or realize while here.

Be clear with this.

Be very clear with this.

Bring all the practices mentioned in this book into your daily life and your art, and as Zosimos said, "Make these things until you become perfect in your soul".[7]

Then turn around and heal the world.

7 Zosimus, *Second Book of The Final Reckoning*, Grecs 3:235–6, *Letters to His Sister Theosebia*: "The Book of Images", p.55.

*"Pray. Read, read, read, re-read, work
and you will discover."*

... that's what Hermes told me.

Appendices

The Emerald Tablet

The *Emerald Tablet*,[1] attributed to Hermes Trismegistus, the bringer of arts and sciences to humanity, is a description of the creation of the universe and its ongoing creation.

All alchemy is, in a sense, an exploration of or a commentary on the *Emerald Tablet,* which is recognized as one of the fundamental texts of alchemy. The earliest known version is found in an 8th-century Arabic translation of *The Secret of Creation* by Apollonius of Tyana –

[1] For a detailed discussion on the *Emerald Tablet* see the author's *Alchemy: The Poetry of Matter.* Or study *The Book of Komarios* and *The Apocryphon of John* in conjunction with the *Emerald Tablet.*

the *Sirr al-Khaliqah* – and it is this text that I translate here. The *Emerald Tablet*'s original Greek text is now lost, leaving only the Arabic and its 12th-century Latin translation, *Tabula smaragdina*, by Hugo of Santalla in Tarazona.

Legend has it that it was found near Hebron in a cave that was the tomb of Hermes Trismegistus. One version tells of an earthquake that struck one day. As Apollonius passed the statue, he noticed that the base had cracked open, revealing a passageway down into an underground crypt. He descended, and there he discovered a seated figure of Hermes Trismegistus holding a tablet of emerald engraved with the text translated on the next page.

"A Truth without doubt, wholly sound,
 that the highest is from the lowest
 and the lowest is from the highest.
The working of wonders is from the one,
 just as all things came from the one,
 by a single governance.
Its father is the Sun and its mother is
the Moon.
 The wind carries it in her belly.
 The earth nourishes it.
Father of talismans,
 treasure-house of wonders,
 perfection of powers.
Fire became Earth.
 Separate the Earth from the Fire.
 The subtler is nobler than the gross.
With skilled work and restraint
 it will ascend from the Earth to
 Heaven
 and descend to Earth from Heaven.

And within itself is the power of the highest
 and of the lowest,
 within it is the light of lights,
 therefore darkness flees from it.
Power of powers.
 It can conquer every subtle thing,
 and penetrate everything gross.
Following the creation of the Macrocosm,
 the Work is completed.
This is my glory, and for that was Hermes named Thrice with Wisdom."

How to View
a Stereogram

With the image directly in front of you, place your index finger in the center between the two images.

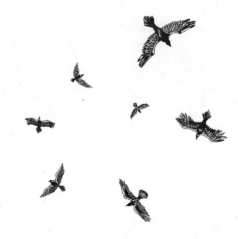

Look at your fingertip and, while keeping your gaze on the tip, slowly move your finger toward your nose.

As it approaches your nose, allow the two images to effortlessly come together. The images will appear as a 3D object floating about 9in (23cm) from your nose.

Circle your finger around the image to strengthen the effect.

Be patient – it may take a few attempts before you see the effect.

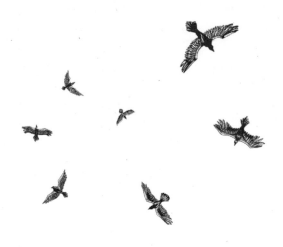

The *Rosarium Philosophorum*

The *Rosarium Philosophorum* (1550), *The Rose-garden of the Philosophers,* is an alchemical treatise about the making of the Philosopher's Stone. The Rose-garden is a metaphor for a collection of quotes, much as a rose garden is a collection of various roses. The sayings concern alchemical theory and practice and are attributed to a range of philosophers and alchemists throughout time. Twenty woodcuts support the text indicating

the stages of the process, with an additional woodcut on the title page showing the gathering of philosophers discussing the work. Translations of the *Rosarium Philosophorum* are readily available and you should study this work as a whole as text and image illuminate each other.

However, you can use the images alone as an exercise in observation. Since the images show a definite sequence in an alchemical process, from beginning to completion, this too can be incorporated into your study and practice of alchemy and your art practice. One way of studying the images is to draw each one on card stock. This will allow you to discover patterns and structures in the sequence.

What follows are the 21 images with their accompanying texts translated and with minimal commentary to help orient you.

The title page illustrates a gathering of philosophers and kings discussing aspects of the art of alchemy, saying things like "dissolve and coagulate", "dissolve the body in water", "he should look to nature", "who wishes to masterfully make our stone". This image is not unique to this text. It has been used in other alchemical works such as *Turba Philosophorum, The Crowd of Philosophers,* printed in 1572.

This image is a symbolic representation of the natural forces and materials at play in the world and in the alchemical work depicted in the sequence. Apply what you have read so far to understanding this image – the Four Elements, the Three Principles, ascent–descent, and so on.

> *"We are the beginning and first*
> *nature of metals,*
> *Art by us maketh the chief tincture.*
> *There is no fountain nor water found*
> *like unto me.*
> *I heal and help both the rich and*
> *the poor,*
> *But yet I am full of hurtful poison."*

The text in the image reads:

Upper part: *animal, mineral, vegetable.*

Streaming from the fountain: *virgin's milk, strong water, water of life.*

Around the fountain: *one is lower animal, lower mineral, lower vegetable.*

These next three images show the preparation
of the first matter, the removal of the extraneous
and the setting up of conditions for the work
to begin.

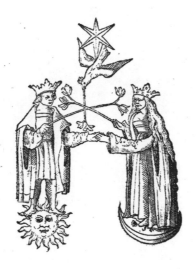

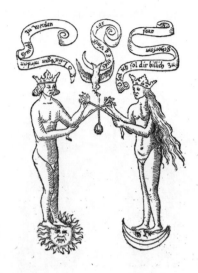

The text reads:

King: *O Virgin Luna will become brilliant.*

Queen: *O Sun I should be obedient.*

Dove: *The Spirit ever gives strength.*

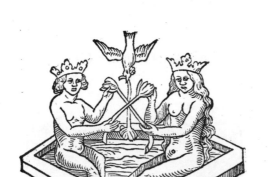

The next six images depict the process of the White Work, which begins with Conjunction or Coitus, shown here.

Conjunction or Coitus

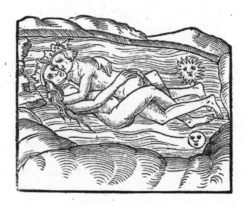

"O Luna, by means of my embracing and sweet kisses,
Thou art made beautiful, strong, and mighty like as I am.
O Sol, thou art to be preferred before all light,
But yet thou needest me, as the cock does the hen."

Conception or
Putrefaction

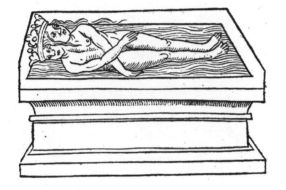

*"Here lie the King and Queen dead.
The Soul is separated with great grief."*

Extraction of Soul
or Impregnation

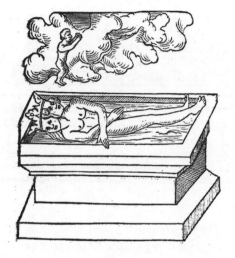

"Here the Four Elements are separated,
And the Soul is most subtly severed
from the Body."

Washing or Mundification

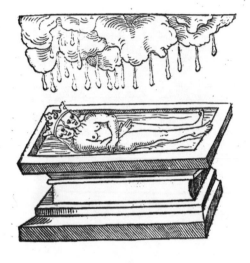

"Here the dew falleth from heaven,
And washeth the black body
in the sepulchre."

Jubilation of the Soul or Its Rise or Sublimation

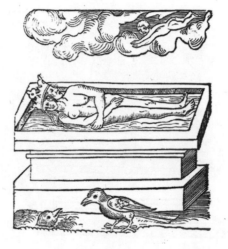

*"Here the Soul descendeth from
on high,
And revives the putrefied body."*

"Here is born a noble and rich Queen
Whom the wisemen liken unto their daughter
She increaseth and bringeth forth
infinite children
Which is immortal pure and without spot
The Queen hates death and poverty
She excels both Silver and Gold and
precious stones
And all medicines both precious and base
There is nothing in this world like unto her
For which we render thanks to Immortal God."

The Red Stage now begins with Fermentation
and continues for seven images.

Fermentation

*"Here Sol is again included,
And is circumpassed with the Mercury
of the Philosophers."*

Illumination

*"Here Sol plainly dies again,
And is drowned with the Mercury
of the Philosophers."*

Nourishment

*"Here Sol is made black like unto pitch,
With the Mercury of the Philosophers."*

Fixation

*"Here ends the life of Luna,
And the spirit subtly ascends on high."*

Multiplication

"Here the water is diminished,
And bedeweth the earth
with his moisture."

Revivification

*"Here the Soul descendeth gloriously
from heaven,
And raiseth up the Daughter
of Philosophy."*

Display of Perfection

The Riddle of the King

"Here is born the king of all glory
There cannot be any created
Greater in the world than he
Neither by Art nor Nature
Of what living creature soever
The Philosophers call him their son
He effecteth all things which they do
And whatsoever men expect of him
He giveth continual health
Gold, Silver, and precious stones
He giveth fortitude, long life, beauty
And Purity. He expelleth Anger,
Sorrow, Poverty, and diseases
Blessed is he on whom God bestows
this gift."

The next three images are a recapitulation of the whole work looked at from different perspectives, as it were.

*"I am the true green and Golden Lion
without cares,
In me all the secrets of the Philosophers
are hidden."*

The Holy Trinity: the Father, the Son, and the Holy Spirit, which crowns the work. They are the Three in One.

Left Banner: *Whose Father is the Sun, Mother but the Moon. And from the Father comes the Son and the Son is the Mother.*

Right Banner: *The dragon does not die without his brother and sister but only by both together.*

Center Text: *Three, One.*

The Resurrection. The Philosopher's Stone.

The matter fully resurrected and able to make change itself.

"After my many great sufferings
and torments,
I rise, glorious, pure, and stainless."

A Simple Circulation and Distillation Apparatus

"The highest is from the lowest and the lowest is from the highest."

The Emerald Tablet

You can make a basic apparatus from a Martini glass and Mason jar. Some Mason jars come with a removable rubber gasket, useful in making a seal with the glass. If the Mason jar is missing this gasket, you may find a suitable one in hardware stores.

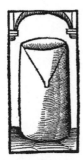

The device is a rather classic one, as you can see in this image from Brunschwig's *Kunst Zu Distillieren*. Simply take a Martini glass[1] and cut off the bottom and assemble as shown.

To cut the stem, follow these instructions for cutting glass rods and tubing, which you may remember from high school chemistry class. Do wear eye protection.

1. Use a hardened triangular file and score the glass stem *once*.

2. Turn the scratch away from your body. Place your thumbs on opposite sides of the scratch and press firmly.

3. The stem should break at the scratch.

4. It's best to wrap the stem in a towel before breaking the stem; this will catch any glass fragments.

5. This is the condenser. File the end of the stem to dull the sharp edges.

[1] A 1l (1½ pint) Mason jar works well for this.

Place this condenser with the gasket in the Mason jar containing the liquid as shown. Filled with ice, it acts like the bowl in Observation #2 (see page 108). The evaporated liquid condenses on the underside of the Martini glass. As the drops gather, they slide down the sides and the stem and return to the heated liquid below. This is the circulation setup.

Circulation setup Distillation setup

To make this into a distillation device, add a small sherry glass as a receiver, as shown in the illustration. This small glass will catch the condensing drops. This is the distillation setup.

The heat source for this work needs to be an electric hotplate. Do not use an open flame.

Alcohol (ethanol) is highly flammable, so always work with an electric hotplate and always with adequate ventilation.

The Distillation of the Spirit of Wine or Aqua Ardens and its circulation into the Quintessence of Wine.

The Renaissance philosopher and doctor Marsilio Ficino notes in his *Three Books on Life* that the Quintessence is in everything but that it is more accessible through certain things.

> ... *"Such things are: choice wine, sugar, myrobalans and things which smell most sweet and which shine ...*[2]

We are most interested in wine and separating its Spirit from the rest of the solution. Wine is mostly water – about 88 per cent – and alcohol (ethanol) about 12 per cent.

Water boils at 100°C (212°F), and ethanol (spirit of wine) boils at 78.4°C (173°F), so when heating wine to 78.4°C (173°F) mostly

[2] *Ibid.*, 257

ethanol evaporates, mainly leaving water behind.

For wine, John of Rupescissa, an early 14th-century alchemist, recommends that you:

> *"Do not take wine that is too watery, nor black wine, earthy, tasteless, but wine that is noble, fertile, flavorful and fragrant, the best you can find. And distill it canonically many times, until you make the best Aqua Ardens you know how to do. Distill it three to seven times: and this is the Aqua Ardens, to which modern doctors have not attained. This water is the matter from which is extracted the quintessence."[3]*

To distill canonically is to have a slow rate of distillation. Early writings recommend that the time between drops is the time it takes to recite one *Pater Noster*. The idea is to have a slow, gentle distillation, do not let the wine or the Aqua Ardens boil. Watch the speed of the drops and adjust your heat accordingly.

✦ ────────────────

[3] Rupescissa. *De Consideratione Quintae Essentie.* 29–30, in Brian Cotnoir, *Alchemy: The Poetry of Matter.* 143ff

When the cup is near full, turn off the heat, carefully remove the Martini condenser, remove the cup, and empty its contents, the distillate, into a clean bottle where you will collect all the distillates from this first round. This is Aqua Ardens and will be around 40–55 per cent ethanol.

Once all the wine has been processed through this first round of distillation, take the Aqua Ardens you saved in the bottle and put it into a clean Mason jar; distill this as you did the wine. Collect the new distillate in a new bottle; this second round will be around 60–70 per cent ethanol. Repeat this process of distilling the previous distillate, leaving more of the water behind and increasing the concentration of the ethanol. By the 7th cycle, the Aqua Ardens will be 95 per cent pure. Because it is so hygroscopic alcohol will always absorb water from the air and finds a balance at around 95 per cent.

The resulting distillate is a very pure Aqua Ardens. To change this into the Quintessence of Wine, circulate it many times. How many? John of Rupescissa says:

> ... *"up to a thousand times, and by continuous ascent and descent it is raised up to such a height, it becomes glorified. It may be a composition almost incorruptible as heaven, and of the nature of heaven. Therefore, it is called the quintessence."*[4]

And when, he continues, after this continuous circulation and the flask is opened, a scent will fill the air that is:

> *"the most marvelous such that no worldly fragrance can equal. It seems to have descended from on high of the most glorious God. So that if the vessel were lying in the corner of the house, because of the fragrance of the quintessence (what a wondrous and sum of miracles it is), by an invisible chain would attract to itself all who enter in."*[5]

This is the quintessence of wine.

[4] *Ibid.*, 30–31
[5] *Ibid.*, 31

On Reading:
How to Read an
Alchemical Text

"Lay hold of my instructions and meditate upon them, and so fit your mind and understanding to conceive what I say, as if you yourself were the author of these things I write."[1]

Hermes Trismegistus

[1] Hermes Trismegistus, *Septus Tractatus Aureus,* Book 2: line 4

Overall, you must consider the text as a whole, in the context of the author's work and the time and place of its writing and publication. Meaning that you should gain familiarity with the religion, philosophy, art, science, and social structures in which the text circulates.

Also, be aware that there is a communication strategy used by alchemical writers known as dispersion, where they seek to reveal their work to others engaged in the work while at the same time hiding it from those more frivolous and unscrupulous individuals. In essence, the practice of dispersion takes an idea, discovery, or process and spreads parts of it over several books or between images and text. So, to understand one book, you will almost certainly need to read several others by the same writer and other writers contemporary with the author being studied. As the alchemist, Rhasis noted, "one book opens another".

And starting with one book, you can consider something read when you have read it three times in the following way.

The first reading is just a straight read-through, beginning to end. Don't worry about what you don't understand, trust that you will and keep reading. Often what is unclear is made clear in the next paragraph or two. If not, keep reading, make notes if you wish but don't dwell; it's crucial to finish the book. When you have finished, what you understand at that point is yours. You know it. You also know the writer's voice, the structure, and the flow of the work, which, along with the blocks of understanding, makes the second reading easier. The second reading should consolidate your insights from the first, deepening what you have understood. In this second round, you stop and dig in when you don't understand something and move on only when you have understood it or are exhausted by it. And when you have made your way through this work, consulting other writings, images, and so on, you then read the text once more for a third time, beginning to end straight through. And when you hit one of the remaining difficult spots, slow down and just meditate on it, let your thoughts flow over the knot, and acknowledge it. Leave it as a question and put it aside for now. In the

ongoing overall work, it will, at some point, be resolved. Too early, and forcing a resolution, might very well obscure a more complete understanding.

Of course, if you are using the text in a material practice, you may need to come up with a tentative statement in order to set up an experiment that hopefully will clarify the text. And this is the beginning of the actual reading of the text, that of bringing the words into practice and the practice back into the words. And your actions and results will illuminate further the meaning and the way ahead.

It really is as the *Mutus Liber says:*

> *"Pray.*
> *Read, read, read,*
> *re-read,*
> *work*
> *and you*
> *will discover."*

Oh,
and that thing
I said about this
being the last thing
I write ...?
 don't count on it.

Bibliography

Rosarium Philosophorum, in the compendium *De alchemia opuscula complura veterum philosophorum*, Cyriaeus Jacob, Frankfurt, 1550

Agrippa, Henry Cornelieus, *Three Books of Occult Philosophy*, ed. Donald Tyson, Llewellyn Publications, Minnesota, 1998

Atwood, Mary Anne, *A Suggestive Inquiry into the Hermetic Mystery*, Trelawney Saunders, London, 1850

Bartlett, Robert, *Real Alchemy: A Primer of Practical Alchemy*, Ibis Press, Lake Worth, 2009

Berthelot, M, *Collection des ancien alchimistes grecs*. 4 vols., Steinheil, Paris, 1887

Bremner, Marlene Seven, *Hermetic Philosophy and Creative Alchemy*, Inner Traditions, Rochester, 2022

Carruthers, Mary, *The Craft of Thought*, Cambridge UP, Cambridge, 1998

Cicero, *The Republic*, trans. Clinton Keyes, Harvard UP, Cambridge (MA), 2006

Copenhaver, Brian P, *Hermetica: The Greek Corpus Hermeticum and the Latin Asclepius*, Cambridge UP, Cambridge, 1992

Cotnoir, Brian, *Practical Alchemy: A Guide to the Great Work*, Red Wheel/Weiser, Newburyport, 2021
 – *Alchemy: The Poetry of Matter*, Khepri Press, New York, 2017

Dalai Lama, *Stages of Meditation*, Snow Lion Publications, Ithaca, 2003

Democritus, *The Four Books of Pseudo-Democritus*, trans. Matteo Martelli, Routledge, New York, 2013

Dionysus Aeropagite, *Pseudo-Dionysus: The Complete Works*, trans. Colm Luibheid and Paul Rorem, Paulist, New Jersey. 1987

Ficino, Marsilio, *Three Books on Life*, trans. Carol Kaske and John Clark, Medieval & Renaissance Texts, New York, 1998
 – *All Things Natural: Ficino on Plato's Timaeus*, trans. Arthur Farndell, Shepheard Walwyn, London, 2010

Flamel, Nicolas, *His Exposition of the Hieroglyphicall Figures*, Garland Publishing, Inc., New York, 1994

Guigo II, *The Ladder of Monks and Twelve Meditations*, trans. E Colledge and J Walsh, Liturgical Press, Collegeville, 1981

Hadot, Pierre, *Philosophy as a Way of Life*, Blackwell Publishing, Malden, 1995

Iamblichus, *De Mysteriis*, trans. Emma C Clarke, John M. Dillon, and Jackson P Hershbell, of Biblical Literature Society, Atlanta, 2003

Ibn 'Arabi, Muhyiddin, *The Alchemy of Human Happines*, trans. Stephen Hirtenstein,: Anqa Publishing, Oxford, 2017

Junius, Manfred, *Spagyrics*, Healing Arts Press, Rochester, 2007

Majercik, Ruth. *The Chaldean Oracles: Text, Translation and Commentary*, Prometheus Trust, Chepstow, 2013

Merkel, Ingrid, and Allen G Debus, *Hermeticism and the Renaissance: Intellectual History and the Occult in Early Modern Europe*, Folger Shakespeare Library, Washington, 1988

Norbu, Nomkhai, *Dream Yoga and the Practice of Natural Light*, Snow Lion Publications, Ithaca, 1992

Paracelsus, *The Hermetic and Alchemical Writings of Paracelsus*, ed. A E Waite, University Books, New York, 1967

Pentcheva, Bissera, *The Sensual Icon: Space, Ritual, and the Senses in Byzantium*, PSU Press, University Park (PA), 2010

Plotinus, *The Enneads*, trans. Stephen MacKenna, Larson Publications, Burdett (NY), 1992

Proclus, *A Commentary on the First Book of Euclid's Elements*, trans. Glenn Morrow, Princeton UP, Princeton, 1992
 - "On the Priestly Art According to the Greeks", in Merkel and Debus *Hermeticism and the Renaissance*, Folger Shakespeare Library, Washington, 1988, pp.103–5

Rupescissa, John, *De Consideratione Quintae Essentie Rerum Omnium*, 1561

Sacks, Oliver, *Hallucinations*, Vintage Books, New York, 2012

St. John of Damascus, *On the Divine Images*, trans. David Anderson, St. Vladimir's Seminary Press, Crestwood (NY), 2000

St. Teresa of Avila, *The Interior Castle*, trans. Mirabai Starr, Riverhead Books, New York, 2003

Shaw, Gregory, *Theurgy and the Soul: The Neoplatonism of Iamblichus*, Angelico Press, Kettering (OH), 2014

Smith, Cyril Stanley, and John G Hawthorne, *Mappae Clavicula: A Little Key to the World of Medieval Techniques*, American Philosophical Society, Philadelphia, 1974

Sutton, Daud, *Islamic Design*, Walker Publishing, New York, 2007
– *Ruler and Compass*, Bloomsbury (NY), 2009

Trismosin, Salomon. *Splendor Solis*, trans. and ed. S Skinner, R T Prinke, G Hedesan, and J Godwin, Watkins Media, London, 2019

Waite, Arthur Edward, *The Hermetic Museum*, Weiser, New York, 1974

Wangyal, Tenzin, *The Tibetan Yogas of Dream and Sleep*, Snow Lion, Ithaca (NY), 1998

Zosimos, *Mushaf as-suwar: The Book of Pictures*, Theordor Abt ed. Daimon Publications, Einsiedeln, Switzerland, 2007

About the Author

Brian Cotnoir is an alchemist, artist, and award-winning filmmaker. A contributor to Frater Albertus' "Parachemy", he is also the author of *The Hermetic and Alchemical* Zines series. His books include *Alchemy: The Poetry of Matter*, *Practical Alchemy: A Guide to the Great Work*, *Alchemical Meditations*, *On the Quintessence of Wine*, and *The Emerald Tablet*, his translations of and commentary on the earliest Arabic and Latin versions of this seminal text.

He has presented workshops and seminars worldwide on various aspects of alchemical theory and practice based on his research. Khepri Press, launched in 2014 with the publication of *The Emerald Tablet*, is the vehicle and portal for his alchemical work.

His film work has been screened at the Museum of Modern Art, Sundance Film Festival, HBO, PBS, and other international venues.

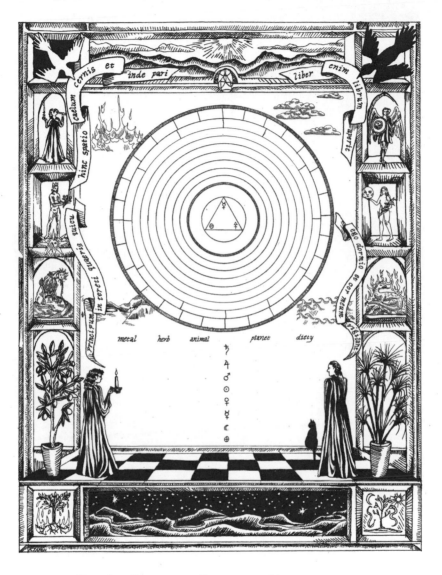

metal herb animal planet diety

Use the Cosmograph to organize your notes.
Copy and enlarge if necessary.

Find a table of alchemical signs you wish to study and copy its contents here.

These are the birds in the book. When you find
a mystic, poetic, mythic, or alchemical meaning
for them, note it here.

 Hoopoe

 Crow

 Vulture

 Pelican

 Phoenix

 Peacock

 Swan

 Egg

 Eagle

 Dove

 Swallow

 Ibis

Use the next few pages to make notes on all that your research has found.